HOW TO
AUDITION
ON
CAMERA

"Alright, so you're the greatest thespian since Sarah Bernhardt. But if you can't get the job, what's the point? While acting is an art, auditioning is a craft—and Sharon knows this world six ways to Sunday. Her book brims with no-nonsense advice and tough love. There's not an ounce of b.s. or filler in here. And I can assure you, from a producer's point of view, that she's telling you exactly what folks like me are looking for."

—Vince Gilligan, creator of *Breaking Bad*

"Sharon Bialy and her merry persons have come up with more great ideas than the Federal Government. And hers actually work. I rely on her tremendously. She has long suggested that any actor wishing to understand the audition process work for a while on the other side of the table. I've never heard better advice. Any actor will profit from her book, and, should they bring a copy along to any audition she and I are running, will surely get not only our attention, but our respect."

—David Mamet, Pulitzer Prize-winning playwright, *Glengarry Glen Ross*

"Auditioning is the most nerve-racking thing an actor has to go through. Sharon's book is a fly-on-the-wall insight on how it's all done, how you should walk into the room, and what you should expect. I really wish I

had read this book when I first started because I could have avoided a lot of cringe-worthy embarrassments. Sharon Bialy is a casting director who truly loves actors, and in her book she openly and candidly gives you all the tools you'll need to walk into the room with confidence and give the best audition you possibly can."

—Krysten Ritter, actress, *Jessica Jones*

"Why should you read this book? The more information you can get before you go into a room, the better! I agree with Sharon that a lot of it has to do with confidence and convincing them you are up for the job and can pull it off. It's their time, their money, and their project. The more ammo you have going in, the bigger the boom. Read the book and you will know what I mean."

—Norman Reedus, actor, *The Walking Dead*

"Sharon Bialy is the very, very best, especially at preparing actors to shine in the room. As a director who has worked with Sharon on multiple projects, I can tell you that she has now given actors the answers they need to prepare for a fully expressed audition."

—Davis Guggenheim, Academy Award-winning director

"Everyone in the business should read this book. As a talent agent, I find Sharon to be respectful of the actors we send in to audition, and she works to get the best out of them. Her taste and expertise in her field are beyond comparison."

—Iris Grossman, talent agent, Paradigm Talent Agency

"I wish I'd had this advice available to me when I started out."

—Bryan Cranston, Three-time Emmy Award-winning actor, *Breaking Bad*

HOW TO
AUDITION
ON
CAMERA

A Hollywood Insider's
Guide for Actors

Second Edition

SHARON BIALY

Second Edition: September 2016
10 9 8 7 6 5 4 3 2 1

Library of Congress Control Number: 2012949028

Paperback ISBN 978-0-88448-525-4
ebook ISBN 978-0-88448-541-4

Cover and interior design by Frame25 Productions

Author photo: Jessie Webster

Tilbury House Publishers
12 Starr Street
Thomaston, ME 04861

www.tilburyhouse.com

Contents

Foreword

When I was asked to write this piece for Sharon's book, it struck me that "forward," the homophone for "foreword," is the perfect word to guide actors as they navigate the choppy waters of a career in this profession. You have to move forward in your thinking and forward in your approach to a character. And you have to look forward to auditioning. Yes, I said look forward to it. If some of the hurdles of auditioning were removed, wouldn't it be more fun? Well, that is exactly the point of this book—to help you sidestep the pitfalls so that you can enjoy the acting.

Sharon gives us really valuable information in this book. As I read it I found myself nodding in agreement. I'm honored to write this for her, but I am equally honored to write it for you, my fellow actor.

Sharon has always been passionate about acting and actors. She's not one of the several casting directors who stumbled their way into that position by answering a "help wanted" ad. Sharon has a keen eye for talent.

As evidenced by her work on our show, *Breaking Bad,* Sharon, along with Sherry Thomas and the rest of the casting team, brings us actors who are perfect in their characterizations for the story we're telling. I've directed a few episodes in the series, and I rely heavily on Sharon's perception of a character's description and her intuition on particular actors. She has been spot on each time.

There is so much to say about the craft of acting that no one book, or even several books, can hope to cover the subject completely. But if a pragmatic approach to auditioning is what you want—and who doesn't?—this may be the only book you'll ever need. I've been acting professionally since 1979. A long time. After finishing Sharon's book, my first thought was, "I wish I'd had this practical advice available to me when I started out."

I'm glad that you do. Have fun, and I wish you the very best of luck.

—Bryan Cranston, Emmy Award –
winning actor, *Breaking Bad*
September 2012

Author's Note for the Second Edition

I never expected four years ago to be writing a revision for *How to Audition On Camera*, yet so much in our business changes from year to year. I felt I owed it to you, the reader and the actor who is working to become an even better actor, to inform you of changes occurring within our industry. Since the initial release of this book in 2012, more and more original content is being aired or streamed in a variety of formats— Netflix, Amazon, and Hulu, to name just a few. Now is a *very* good time to be an actor. How can I tell? Because I can barely keep track of all the content that is available—so much so that the six of us at Bialy/ Thomas & Associates divide and conquer as much as possible in order to stay current with what is airing, streaming, or featured on "old fashioned" live television shows and movies.

Even within our offices there is proof of this volume of activity. We always attach a list of actors that

we have checked and vetted when sending auditions to our producers. It's a list of casting ideas for our network and studio partners. But the list of actors who are *not* available for any given project has gone from one page to *multiple* pages.

Your goal is to become one of those names on that "not available" list. This newly revised and first paperback edition is meant for you—to help you make the most of what you love to do: acting.

One quick note: Words and phrases that are in boldfaced type in the book are defined in the glossary in the back.

—July 2016

Introduction

As a casting director working in Hollywood for more than 29 years, I am constantly asked questions about how to audition successfully on camera. Actors—both novice and professional—are often misled by the myths and obsolete information presented in various acting books. George Bernard Shaw said, "Beware of false knowledge; it is more dangerous than ignorance." My goal in writing this guide is to dispel the false knowledge on this topic. This guidebook is meant to be concise and helpful for you, the actor. I will focus on the art of on-camera auditioning from the perspective of the casting director, the person in the room collaborating with the producers and director on making the final decision. I want you to have a handbook that you can start using immediately and that will help lead you to success.

If you are going to act on camera, you are going to have to learn how to master the audition. As reported in *Variety* in 2012, Google announced its intention to spend $200 million to market the plethora of new

channels launching on YouTube. Those 100 new channels were just the beginning of the "**second screen**" marketplace, which has opened up an entirely fresh medium for actors, something other than film, cable, and network television. How are you are going to get those jobs? The answer is by mastering the art of auditioning on camera. If you learn to master the art of a recorded audition, the work will eventually follow.

I don't have only one philosophy or ideology for auditioning; I think the best actors take their cues from a variety of superb teachers and methods, piecing together the advice that works best for them. However, I insist on a strong and committed work ethic. I have little patience for excuses. If you show up, my expectation as the casting director is that you have done your homework—reading and analyzing the script, working on the scene, making detailed and clear choices, and rehearsing. And rehearsing. And rehearsing. It's called being a professional.

You rehearse so that you are comfortable in the audition. Begin to replicate the audition by taping yourself at home and watching the playback or by practicing with friends or in class. You should commit to practicing every day, even if a camera is your only audience. Practice everything: small parts (five lines and under), a short scene, scenes with multiple characters, and longer (five-page) scenes. The goal

of training is to improve your performance; this is true not only in acting but in nearly every human endeavor. Remember, there are no small parts, just small paychecks. If you can bring something to life in a way that no one else does, it doesn't matter how many lines there are. You don't want or need to keep score that way, and you get the same paycheck and **residuals** whether you recite one line or fifty. Evander Holyfield (four-time world heavyweight boxing champion) stated: *"A champion shows who he is by what he does when he is tested. When a person gets up and says 'I can still do it,' he is a champion."*

The successful actor prepares by replicating every situation so that auditioning becomes routine and comfortable. When you finally go in for the casting director to audition on camera, it should be just another day of acting. We all know that repetition and consistency bring success to musicians, and it's equally true of actors, whose instruments are themselves. To quote Malcolm Gladwell, "The people at the top don't work just harder or even much harder than everyone else. They work much, much harder." And how much does that amount to? Gladwell goes on to say that "researchers have settled on what they believe is the magic number for true expertise: ten thousand hours."

Malcolm Gladwell's ten-thousand-hour rule makes some sense. On its face it sounds like the famous

answer to the question, "How do you get to Carnegie Hall?": "Practice, practice, practice." Practice makes one better in any human endeavor. But actors can put in ten thousand hours of practice by the time they're twenty-one years old. Does that mean their practicing can end? Have they become as expert as they can be? Does doing the same thing over and over for ten thousand hours truly make one an expert in any field?

A newer, more specific theory makes more sense to me. As put forth in the book *Peak: Secrets from the New Science of Expertise,* this theory advocates a very deliberate form of practice to improve one's skill. Constantly pushing yourself beyond your comfort zone and using feedback to identify and address weaknesses is the key to genuine growth, according to this thinking. Weaknesses are addressed not just by practice but by focused, goal-driven practice. This is the key to growth. Remember, auditioning on camera is a craft in and of itself. The rules of engagement are different.

Eudora Welty said the job of a writer is to inhabit another person's skin, whether that person is a saint or an axe murderer. I think the same can be said for acting. The actor must inhabit another person's being— in the way he or she thinks, talks, moves, and reacts. Isn't that the exciting part of working as an actor— assuming a completely different persona for a while and exploring another human being's condition?

Finding the truth about a character or scene can be a very exciting discovery. We are looking for a semblance of truth in an audition because it has a way of affecting rhythm and gesture. I advise you to release mediocrity and have fun becoming an expert. No one can be expert at many things. Isn't acting a great pursuit to be expert in?

Do you choose to be an actor? Or are you just "an actor?" How much are you willing to sacrifice to be a really good actor? According to a *New Yorker* interview with the Pulitzer Prize–nominated novelist Philipp Meyer, who created the AMC television series *The Son* (which I had the pleasure to cast), "you really have to know what making art is worth to you." If you ask actors who have "made" it—and by that I mean supporting themselves as an actor and working most of the year as an actor—many will tell you they were willing to sacrifice everything. I'm not suggesting you must sacrifice everything, but I am suggesting that you be willing to sacrifice a lot in order to succeed at the highest level. In strict financial terms, it's a terrible risk to try to make a living as an actor—or in any creative endeavor, for that matter. If you give 80% to your prep work, you are never going to make it in the long run. You may get lucky a couple of times, but your luck won't last. If you want to succeed, give 100% to your preparation.

What makes an audition work? Fundamentally, you have to engage the viewer. There are many ways to do this, emotionally and intellectually. Come up with your own idea of how to interpret the role and the story.

A great audition creates a complete moment in time, a complete world. When an actor is not afraid to make a specific choice, whether it's right or wrong, the audition will be a success. Your interpretation must hold up within the context of the story and be true to the nature of the character, however, so balance your risk-taking with stability.

I learned early on (from one of my early mentors, casting director Rick Pagano) that you don't write off an actor after a single audition. (We often joke that you get three strikes, then you are out.) Actors bloom and flourish at various stages in their lives and in different climates. That is why we strive at Bialy/Thomas & Associates to set up an atmosphere of success for an actor. Build a foundation with small victories that include mastering the audition.

Remember: Casting directors want you to do your best. I am doing my job as a casting director if I present a myriad of good auditions to the producers and directors, making it hard for them to choose. I want you to deliver a great audition and become one of those hard choices for the producers and directors. Now let's get started!

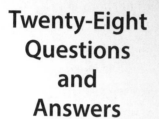

Twenty-Eight
Questions
and
Answers

As a casting director, what are you looking for in an audition?

This is the question I get asked most often. The first answer is talent, and the second (tied for first place) is confidence.

What is talent? To me it's a mystery, one that has intrigued me every day for over 29 years. I try to unlock its secrets, I peek into its windows, yet I still find the answer elusive, mysterious, and worth admiring every single day. Talent is a quality I can't teach; I am simply going to assume that you have talent since you are taking the time to read this. Those five to ten minutes you are in the audition room are a chance for me, as the casting director, to dive into the world, forget about the phones, the schedule, the pressures we are under, and get lost in the material with you. That is

what I consider to be one of the most important parts of an audition, no matter how big or small the role is. Confidence is a different matter; I can teach you how to gain more of that. There are four keys:

Practice

We've all heard the saying, "Practice makes perfect." Let's use the comparison with a top athlete to make you the ultimate actor. Athletes have enormous drive, work hard, and are persistent with their practice. Like an athlete, if you keep at it and refuse to give up, you will win games. The more you practice, the more closely the competition or game (or, in the actor's case, the audition) resembles just another day of practice. Consistency is key. To gain that inner confidence, do the homework. Practice your audition repeatedly so that coming into the office is just another day of doing what you do best.

Please yourself

Don't try to please everyone, because that is a prescription for failure. Please yourself by delivering the work you practiced during your preparation. Aristotle said, "We learn by doing," which is why I advise actors to do it over and over again before they come in to audition. The first audience member you need to satisfy is yourself.

Let go

The next step is often the hardest once you have done the preparation. You then have to "let go" of the work when you are in the audition room. Don't try to hit every step you marked during your rehearsal. It's a trap. Letting go of all that preparation takes experience, but you can take some pressure off yourself by understanding that the goal of your audition is not to book the job but to be remembered and brought in over and over again by the cast-

> "The goal of your audition is not to book the job but to be remembered and brought in over and over again by the casting office. The first audience member you need to satisfy is yourself."

ing office. Professional acting is a "numbers game," and you want to get up to bat as often as possible.

Practically speaking, when you walk into an audition, even if you are nervous (which is natural), convert that energy into being alive and confident. A recently published book on auditions advises actors to let the casting director know they are nervous because it humanizes the actor and the situation. I completely disagree. When I am casting a **television pilot** (or a single episode), millions of dollars are at stake. Producers don't want to hire a nervous actor;

they want to hire an actor with confidence. The actor who is self-assured and secure will relax **producers** and **studio and network executives** into realizing that their product works. That is the actor's job, and actors are often handsomely compensated for that achievement.

Be in the moment

Trust the moment in the room; it may naturally develop into something fresh and exciting. The combination of delivering an honest and truthful rendering of your prepared text and staying in the moment in the room will instill poise and cement your assurance in your abilities. That much is under your control. Confidence seems to appear as if by magic as soon as the actor starts working. The camera innately picks it up, as if it can smell the energy of the actor. The challenge for you is to figure out a way to simulate the work experience as much as possible during your rehearsal so that confidence doesn't elude you in the room. If you perceive the five-minute audition as five minutes you get to "work" as an actor and become a character, your conscious mind will acknowledge that you are "working." Picture those athletes with supreme confidence—you can't take your eyes off them. They beat out all competition. Like it or not, auditioning is a competitive sport, one that involves art instead of athleticism.

How familiar with the project should I be?

When possible you should be *very* familiar with the project. You can learn what you need to know about the acting "style" on a show by watching two episodes. If it is a series that has already aired, there is no excuse in this age of the Internet and YouTube for an actor not to do some research and understand the type of show he or she is reading for. It's all about tone! Even experienced actors sometimes fail to do their "homework." Actors will often mistakenly come in for a serious drama with a comedic bent, or vice versa. You can avoid that mistake. Research the writer, the director, and the producer; there is so much you can accomplish with the click of a button, whether it is on **IMDb (IMDbPro** is worth the investment) or YouTube. It's

important that you understand the atmosphere of each show. *NCIS* is a very different show from *Mom*. Once you see that a show like *Better Call Saul* is subtle, low key, and real, that should influence the tone of your audition. An actor should not audition the same way for a sitcom like *Silicon Valley* as for a drama like *American Horror Story*.

Ever since ABC's *Lost*, series have had to deal with Internet leaks. There are times on many shows when, due to security issues, we cast using "dummy" scenes to avoid giving away story points. That is when it's most important to truly understand the tone of the show. Actors using dummy sides (the pages from the script with which you audition) can only take their cues from the text for their characters, since the sides may not even tell the actor which character he or she would ultimately be portraying on the show. These are the hardest auditions, but they are also becoming the norm for many popular shows. If you encounter such an audition, you must trust that the casting director will guide and aid you through this process. If the casting director tells you that "you nailed it," and you have no idea why, just thank your lucky stars and enjoy the rest of your day.

I heard an interview recently with Rhea Seehorn, whom we cast as Kim Wexler in *Better Call Saul,* the critically acclaimed prequel to *Breaking Bad*. She recounted

her audition experience in the room with me. She was reading "fake" sides that had very little in common with the actual scene. We let Rhea finish her first read using her own instincts (smart ones based on the actual sides). I explained that the character was not a cop and did not have a sister. We had a good laugh. We then discussed the qualities that were needed. Rhea "played" with the scene, trying differently nuanced interpretations, through a second, third, and fourth take (which we used to show Vince Gilligan and Peter Gould) to get her to the next step of a studio test. I told her she had nailed it. I know she walked out of the room questioning how that could be possible, yet she trusted me and left feeling good about herself. She also divulged in that interview that she had been auditioning for Bialy/Thomas for *eight* years and had never booked anything (which I hadn't realized). She came to the correct conclusion that if we were repeatedly bringing her in for auditions, then she was doing her job and eventually the perfect role would come along—and it did!

> "Dummy sides may not even tell the actor which character he or she would ultimately be portraying. These are the hardest auditions, but they are also becoming the norm for many popular shows."

Familiarity with a project will also help prevent novice actors from wasting money on submitting themselves when there are no roles available. If you see a posting on a Hollywood gossip site—or anywhere other than the legitimate casting sites (**Breakdown Express, Now Casting, or LA Casting**)—and it seems too good to be true, it probably is. For those unfamiliar with the sites named above, Breakdown Express is part of Breakdown Services, Ltd, a communications network and casting system that provides a professional means to reach **talent agents,** managers, and actors (through Actors Access) when a project is being cast. Breakdown Services has offices in Los Angeles, New York, and Vancouver, with affiliate relationships in sister companies in Toronto, London, and Sydney. LA Casting and Now Casting provide similar services, representing the best way for casting offices to get information out to actors quickly and securely.

In my office, I have seen false breakdowns on the Internet stating that we have 72 open roles for a television show. It breaks my heart to see how many actors fall for this ploy and rush or Fed-Ex their pictures to the office. If you are familiar with a show like *The Walking Dead,* you will know that the only time we hire that many actors is when we cast for **extras**, which is only done on location by the **extras casting director**, not by our office.

I also caution actors from reaching out on Facebook unless there is a public Facebook page. And while I look at all messages from the "How To Audition" Facebook page, I can't answer 98% of them, which was why I posted a public letter on the site to carefully explain the casting process on *The Walking Dead*. Casting directors deserve their privacy on their personal Facebook pages. Speaking for myself, I use my Facebook page to keep up with family and friends, and spend time every day deleting friend requests from actors whom I don't know. A good place to reach out, if you must, is Twitter—as that is a public platform and you have every right to do so.

With regard to **pilot season,** when auditioning for a pilot, the script is usually available in the casting office. If you have an agent, you should always request that the agent send you the entire script even if you are reading for a small role. Most actors just read the audition scene they were sent and not the entire script. The actor who has read the entire script will understand the tone of the show, the arc of the character, and how important the scene is within the context of the overall story.

Recently, I was auditioning actors for a small supporting role in a movie starring Keanu Reeves. I was shocked when 20% of the actors who came in had not read the script. If you don't read the script, you cannot

compete with talented actors who are fully prepared. It's a waste of your time and mine. It doesn't matter what you did the night before, or that you were tired and didn't have time to prepare. You should have been up reading the script and preparing. You can sleep the next day—or when you're dead.

More information leads to a more successful audition. As Francis Bacon said, "Knowledge itself is power."

Should I be off book?
Can I look at the page?

You need to do what works best for you! Many actors need to be off book in order to work confidently during the audition. I usually recommend that even if an actor has completely memorized the text, he or she keep the sides at hand. You can't prepare perfectly for the spontaneity in the room or the nerves that often accompany auditions. No matter how great you were in the car or the shower, reading for the first time with the casting director changes everything. Having the sides handy to peek at if needed may save you a moment of confusion or lack of focus. Even the most experienced actors forget lines. I have seen actors mess up their lines, stop the audition, and ask if they can go into the hallway to get the sides they left in the waiting

room. While I always say yes, you have to admit the spell is broken, not to mention how the actor must feel running out to the waiting room. That's a tough scenario to recover from.

Further, by holding the sides you remind those viewing the tape that you will be even better when you have the job and are reading with other actors on a set rather than with a casting director in an office. The producer and director will surmise that, once you have memorized the lines and are not just auditioning, your work will improve. It subconsciously encourages the decision-makers to think that this is only the beginning of what can become a terrific performance.

> *"A good rule of thumb if you think you might struggle with nerves or recitation is to memorize the first line, the last line, and something in the middle. That way the camera starts and ends on your face."*

And of course you can look down at the page. It's an audition, after all. Do not get stuck on the page, however. Remember that you are auditioning on camera, and the top of your head is not as interesting as what is going on in your eyes. A good rule of thumb if you think you might struggle with nerves or recitation

is to memorize the first line, the last line, and something in the middle. That way the camera starts and ends on your face and, more important, your eyes, and my producers and director can see you.

Some actors are so nervous they don't want their hands to shake and rattle the paper, so it's best for them to be completely "**off book**" or put their sides on a clipboard. I have hired actors who audition both ways, but I still recommend keeping the sides in hand. You can break this (and every other) rule if something else works for you or if you are bringing something special to the role. When you start getting paid, then it's your responsibility to be "off book."

There is a recent caveat to this advice, however, when it comes to a large guest star role, a heavily recurring role, or a series regular role. Actors who have memorized the entire scene (but still hold their sides) are almost *always* stronger than actors who have not. Actors who have worked for years and have already had leading or supporting roles in series are competing for these jobs, and they almost always audition fully off book. That puts them in a very different place in their preparation from the actor who is looking down constantly and really hasn't done the work to memorize the lines. So when you audition for an important role, I now recommend you be off book—have the material completely memorized.

Some of our shows have three-page (yes, three-page) monologues. Actors who memorize the text completely—usually after only one night of preparation—always impress me. When those actors walk out the door, we say, "That's a pro." The ones who do not go off book *cannot* compete.

Ultimately it's not even the memorizing that's as important as understanding the meaning and intention behind the words. The words won't matter if you don't know what they mean, especially in the context of the story or scene. That's why preparation takes time. There is a tendency to judge the material based on a cursory glance. It's vastly more important to understand it, and that means not depriving yourself of insights that you get when you really look and read carefully. Often memorizing helps bring understanding into focus.

Given that everything now seems to be online and electronic, do I really need to bring in a picture and a resume?

It is true that many casting offices (including my own) download photos and résumés from Breakdown Express or Now Casting and send them electronically to the producers. This is typical if a show is shot on location. Unless you are a very experienced actor, however—with multiple series and significant film roles—you should *always* bring a picture and résumé. The casting office is under enormous stress during pilot season, as it is usually the right combination of actors that gets a show on the air. A show can survive flaws in other departments (such as costumes, sound, or set design), but it will not see the light of day if the pilot is miscast. So help out your casting directors

and make their job just a little easier by bringing your picture and résumé with you, even if it is for a series regular, guest star, or co-star role. If I have it, I will usually give it back to you to save you some money.

Many actors haven't seen or updated their résumés on Breakdown Express or Now Casting (two of the professional sites we often use in my office) in years, so there may be recent credits on your résumé that you want the casting director to be aware of. I have a long history of casting theatre, and I am very interested in an actor's theatre résumé, yet agents and managers often leave theatre credits off the résumés they post on Breakdown Express. Many actors keep those credits on the résumés they have at home. At least once a week I hear, "I thought my agent sent it in." Maybe, and if I am auditioning 45 people for a role, perhaps I missed one, but why take the chance? Bringing your picture and résumé to the casting office is another sign of being a professional.

> *"If you leave your picture in the car or at home, you'll never 'get on the wall.'"*

In my office, our two casting directors, our associate, our assistant, my partner, and I each keep a wall decorated with photos of actors we want to remember for future roles. If you leave your picture in the car or at home, you'll never "get on the wall."

Should I dress in character?

Every teacher and every coach will give you a different answer to this question, but my advice is to "suggest" the character in the way that feels most comfortable to you. If dressing for the role helps you get into character and slide into another persona, then by all means do so.

Producers may appreciate seeing an actor dress for a role, especially if they are familiar with the actor from another body of work. I usually tell women that it's all in the shoes. You will move differently and feel different when you're in Converse sneakers as opposed to Manolo Blahnik or Jimmy Choo. If you are a young actor auditioning for a professional role, it might help you to wear a suit so that you can add to the illusion of maturity. Often it's true that the clothes make the man. If you are auditioning for the role of a wealthy

patron who is defined by his fashion choices, you can create the right illusion if you wear your best suit or designer clothes. When I cast a Western (for example *The Son,* for AMC), most actors come to the audition in Western period wardrobe—and I love it. The women wear their hair and dress appropriately, and I wear Frye boots myself on those occasions, teasing the actors that I am a "method" casting director.

When we cast *The Last Tycoon* for Sony Studios and Amazon, the time period of the pilot was circa 1930s Hollywood. The women had a blast, digging into their wardrobes for something appropriate. For the final tape test, one actress even went to the hairdresser to have her hair done to match the period exactly. It was well worth the investment at that point in the process (she got the role). I love casting period pieces, as the dress exactly conjures the mood that will be present in the scene.

> *"This may be your best excuse not to throw out old clothes."*

You don't have to go out and shop for period clothes. Most actors have cowboy boots and a plaid shirt or older clothes in their closets from another decade (this may be your best excuse not to throw out old clothes). Most actors became actors in the first place because at some point, as children, they liked

to play fantasy games. Enjoy the fact that you get to play at work.

If none of the above makes sense for you, and it makes no difference to you as an actor what you wear, then just wear something comfortable.

You need to do what works best for you. I have often hired actors to play attorneys who came to the audition in sneakers and a T-shirt. I have also hired actresses to play strippers who came in wearing jeans and a plaid shirt.

Should I avoid being the first actor to go in?

This is a common misconception. I understand the concern, as many actors believe the casting director and producer need to hear the text a couple of times before they find their way with the role. While that may be true some of the time, if you are right for the role and give the best reading, it won't matter. I have often turned to my associate after the first actor leaves the room and said, "OK, can I go home now?" I have heard the role read so clearly that I feel that first actor has knocked it out of the ballpark, and I am done with the casting process. In my office, I often take more time with the first actor through the door. If I need time to figure out something in the scene, that actor gets the

most attention and more time to finesse the scene. As the day goes on, the pressures of agents calling and the studio or network needing to be updated can take away from the time I want to spend with actors.

In addition, if you are auditioning for David Mamet, whom I have worked with for the past ten years, you definitely want to be one of the first ones in the door. Mamet tends to want to go back to his office and write, so when he hears the role read beautifully, he often says, "That was fucking great." The actor exits the room, and he asks, "Can I go now?" I force him to stay as long as I can, but I honestly don't think he has ever made it past lunch.

Another piece of advice for actors sitting in the waiting room is not to listen to any insight other actors give you about the audition or the room as they leave. They may truly want to be helpful, but my telling one actor to speak loudly because I can't hear him doesn't necessarily mean that you too need to speak loudly. And the producers may spend a long time talking to one actor and no time talking to you, but that doesn't necessarily mean a thing about you. One actor will find the producers cold and

> "Hang on to your confidence and inner voice; they will serve you in the long run."

another may find them friendly, but that too may have no significance. Just go in, do the work, and remove all the second-guessing, because it doesn't change a thing. Hang on to your confidence and inner voice; they will serve you in the long run.

What is it like in your audition room?

My room changes constantly, as I am rarely in the same office longer than a year. I call myself a Wandering Jew. Since my shows house my partner, my staff, and me by providing offices for us along with the writing, editing, and production staff (though not always in the same location), my audition room can be spacious and comfortable or small and cramped.

As of this writing we have two office locations, and I am on video chat or Skype all day long with my partner, Sherry, or one of my other associates so we can share information between locations. Often we ask actors visiting one location to say hello via video chat to the other, especially if I do a general with a new actor whom I want the entire staff to meet. My location includes two nice-sized rooms, an office for

my associate, my assistant, and me and an audition room for taping actors. Actors usually have to wait out in the hallway.

The audition/taping room has a deep-blue painted wall (my favorite backdrop for filming) and contains a light kit (two external lights with an "umbrella"), an external microphone for better sound, a tiny camera on a tripod, and a chair for the reader. I want the actor to look as good as possible, since I often cast roles right **off the tape** with no **callbacks**. I always try to have two people in the room with the actor when the producers can't be present. Many of our shows are shot on location, so the actor is usually only reading for the casting director without producers. I have one person taping the audition and focusing on making sure you look good, and the other person (myself or a **reader**) reading with you. I usually have pictures of the cast of a show on the wall, either in the audition room or in the waiting area. It's a quick way to remind the actors who they might be acting with in the scene. My office is one of the few that use two people to read with actors. I do this to make it easier for the producers viewing the scene and more realistic for the actor.

I run a friendly and professional room. Friendly, because I compare it to walking into my home; it's my job to make my "guest" feel comfortable and at ease. It has been proven that actors do their best work when

they are relaxed, so being kind makes good business sense. If I can get an actor to feel just a little more relaxed and at ease, it will show on camera. As you likely know, not all audition rooms are such relaxing places. If you end up in a stressful or cold room, why not try to make it a little more relaxed? Say a warm hello and introduce yourself if the assistant hasn't already introduced you. (*Hint*: use both your first and last names, since casting directors are more likely to remember actors who give both names.) In my office I don't **slate** before an audition (the "slate" is when you state your name for the camera), as I like to get right into the scene and let the actor "become" the role. Instead I do a post-slate, asking then for your name and height.

> "If every athlete deserves a warm-up, so does every actor."

I treat every situation differently; there are no cast-in-concrete rules on how to "be" in my room. I often start off talking to an actor and asking questions. This is not a test. Sometimes it's to relax the actor, sometimes it's because I am interested in remembering something about him or her, whether for the audition or for the future. In other instances, especially if it's a difficult or emotional scene, I will sense that the actor

is ready to act and will advise him or her to jump right into the scene; we will talk after the reading.

When Jon Bernthal auditioned for *The Walking Dead*, he sat down and told me how badly he wanted the role and how much he connected with the material. While that may seem like the absolute wrong thing to do in an audition, he was so honest, truthful, and vulnerable, it gave me deep insight into how he would handle the role. (He also already had a body of work.) He even told me that we didn't have to pay him—he would work craft services. We had a good laugh, and I promised I would never tell his agents at William Morris that he had said that. But the reason he got the role was because he was *so* well prepared and so specific in his choices. He didn't nail it on his first take; we "played" with the scene. He was simply right for the role.

Regardless of whether you are right for a role, I will often give you an adjustment or a direction in order to see how you handle direction. I believe that the first reading often carries with it the stress of the drive or subway ride to the audition and the wait in the waiting room. It's the warm-up to the final routine, and if every athlete deserves a warm-up, so does every actor. The busiest season used to be the traditional pilot season, which extended from January through March. Today many pilots are shot year-round. Whatever the

time of year, during the rush of a pilot I sometimes have time only to do the scene and your slate; this has *nothing* to do with you.

Know that every room is different, but they all have one thing in common: they provide you an atmosphere in which to audition and create truth from an illusion with the text you have been given. Go with the flow, and expect every situation to be unique. All you can control is your work in the scene you have practiced.

Before the audition begins, should I be in character or be myself?

I don't believe there are any hard and fast rules for this. If you are doing a simple scene, you should be able to come in as yourself, give a friendly hello, take a beat, and then begin. If you have a very difficult and emotional scene *and you prefer* to come in character, you can respectfully ask the casting director if you can jump directly into the scene and talk after. The casting director will usually agree and may even make the suggestion before you do, having noticed that you've come in character.

When Michael Bowen auditioned for his role in *Breaking Bad*, I knew he was already in character just by seeing him pacing in the waiting room. I didn't

bother to talk or say hello (even though he was the first actor I had ever hired, 25 years earlier!). He was in the moment, and I wanted to capture it and respect his process. I respect the fact that all actors are different.

People often ask whether it's more important that the casting director know who they are as a person or who they are as the character. A successful audition should illuminate both,

> *"A successful audition should illuminate both the actor and the character, but it's the character that is most important."*

but it's the character that is most important. Yes, I want to get a professional sense of you as an actor, including how you handle yourself and your confidence in your greeting. These are often vital clues to how an actor will behave on set. If I sense that someone is overly nervous, distracted, or rude when not in character, it can discourage me from recommending that actor. The Oscar-nominated writer Billy Ray told me, "It's ok for an actor to have an ego—as long as it's in the service of the show."

I have kept notes on every audition for the past 25 years, and I use those notes as a reference guide. If an actor is rude, it may prevent me from calling him in for future auditions. At the end of the day, however, if you are the actor who gives the best read and you are right for the role, you will get the job.

If I have an accent, should I hide it during the audition and pretend to be American?

My answer to this question has changed over the years. If you have a non-American accent and are auditioning in America for an American role, I recommend that you come in sounding American. This will prevent the casting director, producer, and director from focusing on your accent instead of your performance. It will also prevent them from having any reservations about your ability to come across as American. If you can convince them, you can convince the viewer. It is also very impressive to witness an actor who, after completing an audition, relaxes into his or her natural accent. It proves that the actor has an excellent

command of the accent and a good ear. Some actors just leave the room and never let the producers know where they are from. Experienced casting directors and producers, however, will review the résumé and figure it out.

Then again, one can break the rules and still get a job. It's about talent and being right for the role. I have had actors come in with British accents, and when we say "Rolling!" immediately switch to a flawless American accent. It's impressive and it can work, but I still recommend coming into the audition room with an American accent and then comfortably and easily sliding into the scene.

> "If you can convince the casting director, producer, and director, you can convince the viewer."

If the character has an accent, does that mean that I have to do it?

Yes. If a role is scripted for an accent, I will only hire someone who can do the accent. The accent doesn't necessarily have to be perfect at the audition, but the reality is that you have to come damn close. If there is sufficient lead time before a shoot, the actor who books the job can work with a **dialect coach** once he or she is being paid, and will usually be close to perfect on the set.

Simply put, if a role demands an accent, that will be a big factor (but never the only factor) in my choice. When I was casting *The Unit,* the stories took place all over the world. I cast accented roles in almost every episode and often had to cast American

> *"If a role demands an accent, that will be a big factor (but never the only factor) in my choice."*

actors to portray other nationalities. The actors often had only 48 hours between getting the job and putting their accents to use on set. In such extreme cases, the actor with the best audition accent is usually awarded the role.

Should I sit or stand?

That depends. If there is a chair waiting for you and you want to use it, the obvious choice is to sit. If the scene requires you to stand, you can let the casting director know that you are going to stand (that will give time for the camera operator to adjust the tripod and camera). If you are a beginning actor without much experience, I would suggest sitting so that you don't have to worry about your physicality. I can usually spot novice actors because they don't yet have complete physical control, especially when they are nervous. I typically shoot from the waist or chest up, so the producers viewing the tape won't know if you are sitting or standing. If sitting will help you relax, then sit. If sitting zaps your energy, then stand.

I would estimate that actors sit for auditions 75% of the time, but the choice is really yours and may change from scene to scene. If you are unsure, ask yourself whether the character would be sitting or standing in the scene. You can also ask what the **framing** is if that will help with your audition. If you choose to stand, you can use the chair as a prop to lean on. Another little trick is to lay the sides on the chair if, for any reason, you wish to have both hands free.

> *"If sitting will help you relax, then sit. If sitting zaps your energy, then stand."*

If you are standing and you notice that the camera operator or the casting director has the camera at the wrong height, you might want to let the camera operator know that you will be standing for the entire scene. That will usually remind them to raise the tripod without sounding like you're telling them how to run the audition. If you are taping at home, make sure your reader and the camera are at your eye level.

Can I ask the casting director a question?

The answer is, only if you really have one. Too often, actors ask questions because someone has taught them that a question is a good way to start a conversation with a casting director. It isn't necessary to initiate small talk. Before you ask the casting director a question, screen it as follows:

- Is the question something I could have answered for myself if I had prepared properly?

- Is the question something my agent or manager could have answered, such as "When are callbacks?" or "When does this shoot?"

- Is the question something the assistant at the front desk could have answered for me?

- Is the answer in the text?

If your question survives this pre-screening, of course you can ask it. Knowledge is power. And if you do decide to ask a question, don't seek permission by saying, "Can I ask you a question?" Just ask it clearly and succinctly, and then be prepared to take the answer on board and use it constructively, even if it requires you to make a serious adjustment in your audition.

> *"When you ask a question and get an answer, it is your job to factor in this new information."*

When you ask a question and get an answer, it is your job to factor in this new information. If you don't absorb and use the information given to you, you didn't really pay attention to the answer, and the casting director will note that. If you don't listen or adjust in an audition, you may not do so on the set either.

If my sides contain multiple scenes, how much of a transition should I take between scenes?

This is a perfect example of a good time for the actor to ask a question in the audition room. You might want to ask, "Will we be stopping between scenes or are you going to keep the camera rolling?" The answer will be very important for your audition, because if I keep the camera rolling (and sometimes I do), you will want to mark your transitions between scenes with a still beat or two before beginning the next scene. There is no need to go off camera or turn around. The less you make of it, the better.

The reason I often audition a role using multiple scenes is that there may be aspects to the character that

only emerge during a later stage of the script. Producers want to know if the actor can hit different notes and understands the arc of the character. In my audition room, I like to stop the camera between scenes, give the actor a moment or two, and then cue the next scene with "Stand by" and "Rolling." This is yet another reason the actor needs to be fully prepared; it isn't easy to switch gears to a new arc of the character after only a 30-second break. This is the challenge for the actor. An important tool of the trade is the ability to move fluidly from one emotion to the next. You can try taking a quiet (I repeat, quiet) cleansing breath before moving ahead into the next scene.

> *"Try taking a quiet (I repeat, quiet) cleansing breath before moving ahead into the next scene."*

When actors ask me if they can go straight through without the camera stopping—and many do—I always accommodate the request. But I don't recommend it. When you're given even a brief opportunity to focus on what you want to accomplish in the next scene, it seems wise to take it.

If the scene starts with my character off camera, how do I block that in the room?

This is another good question to ask. If you haven't been able to figure out the **blocking**, go ahead and ask for help. Usually you'll be able to see where the camera is pointed or the chair is placed, and two or three small steps will move you off camera. If you plan to walk into the frame, let the camera operator know so he can frame you properly (especially if you will be moving from standing to sitting). You want to be sure that if you start off camera, you *don't* start the dialogue until you are in frame. That is a common error. Given so little time in an audition to establish a character, you want every moment on camera you can get.

Usually when a scene starts off camera, I just have the actor sit and wait until the dialogue begins so there isn't much pressure to stage the scene. It's hard to replicate a "walk and talk" scene, the type of scene we see so often in film or in any work by writers like Aaron Sorkin. If you end up sitting during a moment or scene that will eventually be shot in motion, you have the added responsibility of coloring your voice and choices with the energy that comes naturally from walking. That is why auditioning is so much harder than acting. You don't have the luxury of realistic movement. There are no lights, no makeup, and no fellow actors to elevate your performance.

> "You want to be sure that if you start off camera, you don't start the dialogue until you are in frame."

Stick with this mantra: Simplify the audition so that the work is as believable as possible within the constraints and pressures of the casting room.

If there is a stage direction that I clearly
cannot do, should I just ignore it?
Should I do something else instead?

When confronted with an unrealistic stage direction,
ignore it. It isn't what's important. Let's use a kiss as
an example. You don't need to mime or blow the kiss.
Focus on what the character is saying. If you want,
take a beat. Don't kiss the casting director. Believe me,
the writers know there is a kiss there. I often hear the
excuse that it's difficult to do a romantic or love scene
with a casting director, especially when two same-
gender people are reading a heterosexual scene. Tough
luck. Many actresses have romanced me. Like it or
not, it's your job if it's in the scene. Focus on the text

and what your character wants and let go of worrying about anything else.

Another good example is a scene in which your character is driving a car. You do not need to mime gripping the wheel. Just sit in the car and remember that you are the driver (or perhaps a passenger). Most importantly, realize that "in the car" scenes are shot extremely close up, and you should adjust accordingly in the audition. If you're the driver, remember that you can't look at the other character for long—you need to focus on the road in order to create reality in the scene. Conversely, if you are the passenger, perhaps you need to just glance out the windshield and then focus back on the reader.

Weapons present another challenge for auditions. So many scenes have a gun or other weapon in them, and it's an important part of the scene. It would seem obvious not to bring a gun (though I have had that happen) or a knife to an audition. Some actors will ask if they can use a toy gun, since it's an integral part of the action. My recommendation is not to use anything, but keep your hands clasped together. Many teachers will disagree with me, but no one wants to see you use a dangerous prop in an audition. I think the toy gun or cell phone (often used) look ridiculous. If you feel strongly about using a prop, show the casting director that it's a toy and gauge the reaction. If

the casting director seems comfortable, go ahead and use it, but if you are perceptive enough to sense that the casting director is uncomfortable, then show your flexibility and say, "I'll just go ahead without it." Your willingness to adjust on the spot will be impressive.

Fight scenes or action scenes are particularly challenging. The actor usually only needs to give a suggestion of movement unless requested to show off specific physical skills (usually at a callback). The actor does not need to mime a fight with another actor who isn't there unless

"*Your willingness to adjust on the spot will be impressive.*"

he is specifically asked to do so by the director or **stunt coordinator**. Recently I was coaching an actor for an audition on a big-budget studio feature (one that I was not casting). He was auditioning to play a young king, and the scene called for the king to stick his sword in the ground, slap the character he was talking to across the face, pick up a cloth, and touch the material. The actor began by miming all the actions, and it looked ridiculous on camera. What was going to get the actor the job or prove that he was comfortable in the role was not his ability to mime but his ability to convey a kingly power, presence, and bearing. The only blocking necessary was the suggestion

of a slap, and the rest was in his ability to "control" the scene and be completely comfortable with power. Action can always be added later. At his callback, the casting directors thanked him for being the first actor of the day not to overact and play at being a king. The casting of a king will depend first and foremost on which actor conveys most successfully in his audition that he is "to the manner born." Any king is filled with supreme confidence and a sense of entitlement.

What do I do if there are multiple characters in a scene, but only one reader in the room?

I recommend that you look at the one reader in the room for each character other than your own. You'll be able to connect with someone who is looking at you and listening to you, and that's a lot easier than trying to make a human connection with a wall. There are actors who can do it well, but not many.

Your job in the audition room is to make the scene feel as real as possible, and that is easiest when you give yourself a scene partner. In my office there are almost always two people (usually the camera operator and myself) reading with the actors so that scenes with more than two characters look and feel real. I realize

this is not the norm, because most actors are surprised and grateful for the way my office conducts these readings. There are times when each of us (casting director and reader/camera operator) may be reading two or three roles (i.e., in six- or seven-person scenes).

Ideally, the reader will make slight adjustments for each character, but readers are not actors; it is your responsibility as the actor to shift your reactions and responses to the different characters. For example, the way I speak to my mother is very different from the way I speak to my daughter or my sister-in-law. The producers and director should

> *"The producers and director should see and hear the subtle differences in your relationships. If you get two readers in the audition room, be sure to use them both."*

see and hear those subtle differences in your relationships. If you get two readers in the audition room, be sure to use them both. If you get confused, ask them to remind you who is reading which role so you are clear before you begin the audition. When in doubt, look to the person who is speaking to you, no matter how you prepared it. That's the challenge of working in the moment and remaining facile and spontaneous.

Should I opt to be a little bigger and get pulled back by the casting director rather than risk not doing enough?

Again, although the typical advice is to "go in bigger" because you can always be adjusted to do less, I disagree. First, play to the size of the room—most auditions take place in a small office. Second, be aware of the medium. Even if you are auditioning in a large office and six producers are sitting on a couch, you are still being taped and must audition for the camera.

Auditions are typically shot in a medium close-up (chest and head), and this is extremely important to keep in mind, especially when you are rehearsing. I would say that 95% of the mistakes that even seasoned actors make involve going too big (too much

acting) for the on-camera audition. I usually have to pull actors back (direct them to act less).

Sometimes you will get an opportunity for adjustments, but other times you won't be afforded a second take and will be judged on what you do the first time through. The director and producer may believe that your natural instinct is to be too big for the camera. Since you are being filmed close up, every movement you make needs to be economized for its effect on camera. Often the most interesting moments are the quieter ones, when I observe an actor thinking, listening, or absorbing what is happening around him. I don't believe that an underpowered or underplayed moment will cut the force of the acting. I can often hear the words more clearly when they're more normally inflected.

> "Since you are being filmed close up, every movement you make needs to be economized for its effect on camera."

Do you recommend making the most straightforward or the most interesting choice when auditioning for film or tv?

Every actor makes choices when portraying a character. You should try to make conscious choices that make the role memorable and real. My mantra is to always "serve the text." Keeping that in mind will help you make the right choices. Don't pick something just because it might be interesting. Rather, think about what might work for the character and the situation. Ultimately your choices must be believable.

Your choices should include subtle shadings. You want the camera, and ultimately the viewer, to see the character in a real moment. Something as small as a

glance up at the ceiling, a smile, a laugh, or a certain way you pause can make you stand out and get a role. I call it the actor's signature. After doing your prepara-

> *"If you make a distinct choice, one that serves the text, you will be remembered."*

tion, consider whether your own signature is present in the work. There is a fine line between being coached for a part, by an acting teacher or even yourself, and being present, available, and open to true emotion in a way that is very powerful. Even if the text is only five lines long, *you* can make a specific choice that will put your stamp on the role. We have all heard, "If less is more, is nothing everything?" I can tell you it's not.

From a competitive point of view, if you make a distinct choice, one that serves the text, you will be remembered. If a casting director and producer have sat through 25 auditions, it could be that one lilt of your voice, or the hint of an unexpected smile, or a moment of reflection that makes your work stand out. It does not have to be a big choice. Give at least three truthful moments, and you will have done your job.

How much can I improvise?

You should not improvise much unless you are auditioning for a comedy where you have been given permission to do so, or it is obvious that it is within the style of the show or the creator's background. When you are rehearsing you can improvise as much as you like. I believe in this method. Improvisation helps actors integrate the deeper meaning of the text, begin to access a more natural approach, and get comfortable with the scripted dialogue. But I advise very little improvising at the audition itself.

When I am casting cable television shows, which actors know are more lenient with language than network shows, an actor will sometimes throw a couple of *fucks* or similar into his or her audition. Nine times out of ten it does not serve him well. It is also worth noting

that you will not be able to improvise in the performance, no matter how honestly you may come by the exclamation. If an extemporaneous word or two comes out of your mouth organically—I repeat, organically—don't worry about it. But when you get to the set, you *will* be doing the dialogue as it is written on the page.

At times, the writing is truly not very good, and the actor subconsciously improvises a little because what's written on the page just isn't working for the character. Sometimes (for lack of a more elegant characterization), the writing just sucks. Your job as the actor is to improve upon the writing, not by rewriting, but by adding nuance and shading. Yes, it's unfair, but it's a reality. I cannot tell you how many times I have read a scene, cringed, and then watched a talented actor come in and make it work.

When you do make a small adjustment in the dialogue, a smart writer/producer will sense it and may even incorporate it in the next draft of the script. Most of the time, however, the writers are better at writing than anyone else. They want to hear what works and what doesn't so that they can revise it themselves. Trust the great writers; Vince Gilligan, David Mamet, Aaron Sorkin, Frank Darabont, Glen Mazzara, Philipp Meyer, Billy Ray, Peter Gould, and Shawn Ryan are superb storytellers. They know how to turn a phrase

and modulate a dialogue better than an actor. That is why they are successful writers.

My experience with comedy has taught me that if you change the writing you will often ruin the joke. Not all writing is Shakespeare, but good comedy writing requires the words to be laid out in a designed order. Punctuation can be particularly important, as it will affect the timing of the delivery. Many comedies demand a skillful improviser. You should have a sense of that before the audition.

> *"Your job as the actor is to improve upon the writing, not by rewriting, but by adding nuance and shading."*

Recently our office cast two shows for HBO, *Vice Principals,* starring and created by Danny McBride, and a pilot for Bill Hader. Both artists are incredibly skilled improvisers and wanted to see how facile the actor was with improvisation skills. We often used our assistant Alyssa Morris, who is fantastic at improvising, to read with actors on those shows.

You have to be quick on your feet, be in the moment and not be afraid to "play," especially on a callback reading with the star of the show. Remember, that is "fun" time, and the actors who have the most fun and use the text as the jumping off pad tend to book the role.

For dramas and comedies without the need for improvisational skills, I would trust the writer unless you truly believe you can make it better—and if you can, change careers, because TV and film writers make a lot of money.

Actors who can handle language fluidly will usually get cast over ones who rearrange words to suit themselves. If you improvise some dialogue during your audition and the director or casting director asks you to do it again as written, make sure to stick to the text on the second take. We are trying to gauge in those five minutes what your instinct will be for following direction when on the set. *Hint:* if you are given a second take, even if *not* asked to stick to the text, do the second take precisely as written; having used improvised dialogue on your first take, take the chance now to show what you can do with the script as written.

Most directors and writers won't care if you change a word or two as long as they can sense that it was an honest mistake. One might think David Mamet would want an exact rendering of his script, but he doesn't care at the audition, because he understands that an actor is auditioning. You can be sure, however, that he will care the day you are filming on the set. If you doubt my advice, just ask yourself which of you has won a Pulitzer Prize.

If I mess up, can I start over? What
if I am toward the end of the scene?
And can I start over a second time?

In general I recommend trying to move forward past
any error and continue with the scene. If you mess up
near the beginning or make a big enough error that
you feel you cannot get yourself back on track to com-
plete a truthful reading, then yes, you may start over.
Be aware, however, that you may not have messed up
as much as you think, and starting over imposes added
pressure not to make the same mistake twice. You will
have broken the spell for the casting director, who
may have believed your portrayal despite the error.

Nevertheless, it's human to err, so try it again if you
feel you must. Actors fail to realize that mistakes often

create the most wonderful and spontaneous moments in an audition. A slip can be an unintentional gift; reward the gaffe and use that split second to be in the moment. You may just have created the most believable and original moment of your audition.

If you have a longer scene and you err at the end, I recommend that you plow through it. It's hard to go back and repeat a longer audition, especially if there is a waiting room full of other actors and the casting director is under a time pressure. Casting directors are part of the production team, and we understand the pressures of directors and producers on a set. If you plow through the scene, we know that you can do the same on set, and part of the take may be salvageable in the editing room. You are proving to the casting director that you understand what it means to be on a working set.

> *"A slip can be an unintentional gift; reward the gaffe and use that split second to be in the moment."*

I do not recommend starting over a second time. A casting director appreciates your moving through a mistake. It proves that you are taking everything in and using the spontaneous experience in the audition room. If you are right for the role and the casting

director is interested, you'll be offered a chance to do it again—you won't have to ask. You need to understand that casting directors want to present many strong choices, and if their tape looks good, they are doing their job well.

Casting directors don't want you to fail. Directors and producers are hoping when you walk in the door that you will be "the one" to make it all work. If your error has ruined what could have been a good audition, most likely I will ask you to do it again. But I know a number of actors who *always* ask for a second take or purposely mess up in order to do it again. This practice is annoying, and I remember. That is my job. I am much less likely to invite such actors to audition for the next project.

How can I find out who is going to be in the room?

Usually your agent will tell you. Many agents or managers will ask who will be in the room when they take the information for an appointment. If you don't have an agent or manager, you could call the casting office yourself, but I don't recommend it. The phones are ringing off the hook, and it is added pressure on the overworked casting assistant to answer that many calls. In the end, it shouldn't matter.

Actors often want to identify the most important person in the room in order to pay that person the most attention, but your focus should be on the material, not on who is in the room. **Show runners**—i.e., producers—often have to leave the audition room to

juggle fifty other responsibilities and keep the show up and running on time and on budget. At such times they always say to the people remaining in the audition room, "If you love the next actor and think he's the best choice, email the audition file or a link to it and let me know." The best collaborators trust each other. If the **executive producer** walks out of the room, it does *not* mean you won't get the job. Our shows and the actors who are cast on them are living proof that you can book a huge job with just the casting director in the room.

Many actors get very nervous if a particular writer is in the room. I saw the most experienced actors shaking in their shoes when auditioning for Neil Simon or Aaron Sorkin. The same thing has happened with David Mamet. I even asked David if I could stop introducing him because it made actors too nervous. And I empathize—I was

> *"Your focus should be on the material, not on who is in the room."*

very nervous when I met him for the first time, too! If you get nervous auditioning for a particular person, try not to focus on him (or her). Instead, imagine that you are auditioning for someone familiar who makes you feel comfortable and respected.

Accept the spontaneity of the room, and don't intellectualize or try to guess who will make the decision or who is in the room. I promise you, I have cast actors who auditioned after every member of the team had left the room because we were running behind. If I believe the last person of the day is the best person for the role, I will email all the producers and send them a link to the audition, and sometimes that last person gets the job. The real reason for knowing who is in the room is to educate yourself so that *if* someone engages with you on a personal level, you understand who is talking to you and the context of the conversation or questions. For instance, if you are asked what it was like to work on a certain play or film, you should probably know if the person asking the question wrote or produced it.

I highly recommend reading the "trades," the industry publications that provide vital information for working actors. Actors should read the *Hollywood Reporter, Variety, Deadline,* and especially *Backstage* magazine, where so many open calls for actors are posted.

Should I be insulted if only the casting associate is in the room? What if the casting director is there but no director or producer?

While these questions don't pertain to the skill set needed for auditions, I felt them significant enough to address. The answer is a resounding *no*. Among the variety of reasons for the casting associate to be the only person in the room, he or she may be fully responsible for casting many of the roles in a particular project, be it a television episode or a feature film. It can be challenging to the ego if you are a seasoned actor auditioning for a novice associate, but that should not be your concern. Your concern is to do the best audition,

be remembered for your excellent work, and either get that job or be brought back for another one.

Any casting associate who is a member of the **Casting Society of America (CSA)** will be experienced and professional, and by working with the next generation of casting directors, you get the opportunity to ensure your future and longevity as an actor. Do you want a lengthy career or a brief one? Casting offices often train their associates for years, until the time is right to let the associates cast some roles themselves, before they eventually graduate into full casting directors. Check your ego at the door and do the same work for an associate that you would do for Scott Gimple or Steven Spielberg.

Casting directors have to take on multiple responsibilities. At times they have to be on the phone negotiating an actor's deal with an agent or reasoning with a producer or, more often, studio and network executives. They may need an associate to replace them in the taping room at such times so they do not fall too far behind. I have complete faith in my associate, Stacia Kimler, or Russell Scott and Gohar Gazazyan, the other casting directors at Bialy/Thomas. As far as I'm concerned, you are lucky if you are in the room with them. Many actors who have come into our office have booked a job because an associate gave a specific direction that enhanced their performance.

And don't be insulted to be in the room with the casting director rather than a director or producer. It's a waste of energy. If the director and producer are not in the room, there is a good reason. *The Walking Dead*, *Better Call Saul*, *Halt & Catch Fire*, *Gotham*, and many others (including some not yet released at the time of this writing) are shows that shoot on location, yet we cast the guest stars in Los Angeles or from self-recorded auditions sent in from around the

"If you look at every occasion as a glass half full instead of half empty, you will likely have a longer and more fulfilling career."

country. I can never have the director in the room for those shows, because the director is on set at the location. The producers are often in the writer's room, on set, or in the editing room. Thank goodness Giancarlo Esposito, Jonathan Banks, Kerry Bishe, Mackenzie Davis, Rhea Seehorn, and Ross Marquand (among many others) showed up for their auditions without an ego (or at least sublimated it) and went on tape with "just the casting director."

Some actors even do better without the pressure of too many producers sitting on a couch watching them audition. Casting directors are often more relaxed without the stress of so many voices in the room. We

may take a little more time if there's no director or producer fidgeting beside us. If an actor is off base or has made a strong choice, but the *wrong* choice, I have the luxury of taping the scene multiple times until the actor delivers his or her best performance. I cannot do that when I have a room filled with writers and producers. If you look at every occasion as a glass half full instead of half empty, you will likely have a longer and more fulfilling career.

If I am given sides for a role I am not auditioning for, which character do I focus on?

This is a fairly new phenomenon, but one that happens often now within our office on a variety of shows. One reason is to maintain the secrecy of a show such as *The Walking Dead* or *Gotham*. Another possible reason is that only one scene has been written to introduce a character who will assume a much larger role in future episodes or seasons. In the interest of time, our show runner will often ask us to use the sides of one of the established characters on the show or one already cast in a pilot. This is tricky and confusing for the actors who are auditioning, and who have been taught to

respond to the text and take their cues from what a character says.

My advice is to study the character description of the role you are up for and alter the choices you make to reflect that character. The character in the sides you've been given has already been cast; what is needed now is not a twin but a contrast to that actor in tone, feeling, and most likely physicality. Think about the role you hope to be cast in and modulate and adjust your choices to reflect that character using the sides you were given as a roadmap.

> *"Study the character description of the role you are up for and alter the choices you make to reflect that character."*

What about new media and web series? Are those auditions different, and can I create my own content?

One of the most exciting things about today's new platforms is the variety of mediums available to viewers and actors. Many actors are creating their own content and putting it up on the web, either as a webisode series or just a series of home videos.

Yes, you can do it yourself. There are established webisodes that are produced and created by seasoned professionals, and many actors are auditioning for these. Interestingly, the same rules apply for these auditions as for all on-camera auditions.

It's one of the reasons why being an actor at this time in the history of entertainment is so thrilling.

Make sure your work is well written, shot as simply as possible, and can withstand the test of time (at least a year—you can always take it down later). Many of the top talent agencies have a person dedicated to surfing the web and looking for new talent. Even in our office we have viewed webisodes or homemade content when our interest is piqued. I personally tend to lean toward comedy and more professionally produced web videos (like the successful *Between Two Ferns* on the Funny Or Die website) but I have been known to view other smaller,

> "Many of the top talent agencies have a person dedicated to surfing the web and looking for new talent."

more homegrown Internet series like *Facetiming with Mommy,* created by Olivia Hamilton, which spoke to me as a mother. Make sure you get objective people you respect to review your original content. Don't ask your spouse, your brother or cousin; instead, look for someone who will give you good, constructive criticism. When you put something out in cyberspace, you don't want it to come back to haunt you.

Many people ask me if we cast actors due to their social media presence or their Twitter following. We do not. We base our decisions on the best and most exciting actor for the role—whether he or she is unknown

or a seasoned professional. Vince Gilligan taught us with his vision; he was a true leader, which was why *Breaking Bad* changed the environment of television. He encouraged us to cast *actors,* not movie stars or celebrities. We especially looked for "unknowns" to fill out the roles, so the actors would inhabit Vince's world and seduce the audience into his creation.

What about self-taping? When is it appropriate and should it be done?

Self-taping is 10 or 20 times more common today than it was when I wrote the first edition of this book in 2012. This is progress for actors all over the world. It means you do *not* have to live in New York, LA, or London to book a job in television, film, or new media.

Self-taping by invitation of the casting director is one thing; unsolicited self-taping is another. We do not accept unsolicited tapes in our office, whether they come from the general public or talent agents. It is too overwhelming to sift through thousands of tapes, and if we tried to do it we wouldn't be able to do our day job.

But we receive self-tapes by invitation from actors all over the country and the world, and we even hunt

actors down when they are on vacation (ask Lauren Cohan about *The Walking Dead*). Here are some very important tips to remember when self-taping for a job:

- Hang a blue sheet on the wall behind you. Deep blue is best, but gray or another solid color can also work. If you absolutely can't do that—if you are in a hotel, for example—take any pictures off the wall and use a blank wall as a backdrop, and make sure you're *not* near a mirror or window.

- Make sure the person running the camera (or cell phone) is at your eye level, not shooting up or down, because we need to see your eyes.

- Read *with* someone, even if you have to call up room service. Do not just recite your lines. You won't get the job. Try not to record your own voice doing the other lines and then responding. Your timing will not be natural. Even a bad reader is better than no reader at all.

- If you have a tripod-mounted camera (the best setup), have your reader stand next to the camera and speak quietly. Your voice should be the loudest and clearest on the tape.

- If you are taping at home, it's easier to control the variables. You can purchase an inexpensive light kit on line, with umbrellas that you

can use over and over (it's also a great way to practice). If you can't afford a light kit, natural lighting from a window behind the camera or to the left of the actor will be enough. You can also fill the area with overhead lighting.

- The audition should be filmed starting with a medium close-up and then, if possible, a close-up head shot focusing on your face.

- Do not wear a hat or anything that will shadow your eyes.

- Slate before or after the audition, stating your name clearly and including a full body shot—you can have someone pan up and down quickly.

- Check for sound quality *before* you send your tape to the casting office.

- Send the audition in a *private* link—*not* a public link on YouTube.

- If possible, have your name typed on a card that opens the audition and again at the end with a listing of how to reach you (agent, manager, or cell phone).

- If you can send more than one take, we appreciate that. Send the takes in separate links to make it easier for the casting office to edit and then upload to the site we use to send auditions to our director and producers.

Actors often ask why they should travel to an audition with a casting director if they can self-tape. One reason is that a good casting director can help guide you toward the vision that the creators of the show want to see fulfilled. Another reason is that an audition in person can initiate a long-term relationship with the casting director that could be useful over the course of your career.

"Even a bad reader is better than no reader at all."

I don't encourage actors to fly in if I don't have a director or producer with me in the room, because it's so costly. I tried to convince Chad Coleman to self-tape in New York for *The Walking Dead,* but he didn't listen to me—he followed his instincts and flew in for his audition. I guess he was right. But self-taping can and does work.

What are your pet peeves?

My biggest pet peeve is an actor walking into the audition room unprepared. Preparation is not just the actor's homework; it's a part of the job. In my office, next to the sign-in sheet, we have a quote from the great screenwriter Billy Ray: "I'm not talented enough to be unprepared, are you?"

I'm not interested in excuses. Have I made exceptions? Of course I have. When an actor tells me his wife had a baby a week ago and he's operating on little sleep, I definitely empathize. That's what happened with Andrew Lincoln, who plays the lead, Rick Grimes, in *The Walking Dead*. After his initial **self-tape**, my partner Sherry Thomas and I discussed how perfect he was for the role; his talent and his understanding of

the character were fantastic. In order to give him his best shot with the producers, we asked him to re-tape after reviewing some notes we'd gleaned from Frank Darabont's feedback on previous auditions. Even though he was completely sleep deprived, Andrew agreed to re-tape his audition the next morning because we had a deadline to meet. He got the role.

When Norman Reedus first came in to audition for *The Walking Dead,* he told me straight up he was terrible at auditions and rarely booked a job that way. He was right. His first audition was not the best, yet he had something very special, and you could see a whole life in his eyes. He didn't get the role he originally auditioned for, but we did offer him another role months later that had been written into the script. I think most readers will know what happened with that.

It is a part of life that at times you won't be feeling your best. If you are truly sick and cannot do a good job, try to reschedule your audition. If you just can't do justice to the role, cancel.

Or suck it up and deal with it. When I was casting the pilot for *Breaking Bad,* Anna Gunn failed to show up for two scheduled auditions. I called her agent and discovered that she was sick, her children were sick, and she was feeling miserable. Because I knew Anna well (she had been a reader for me on countless theatre auditions when I needed an actress who could handle

anything from Shakespeare to Moliere), I took the liberty of calling her at home—something I rarely do, as agents really don't like it. I told Anna, "You have to come in for this. You are perfect for this role. Did you even read it?" "No," she replied, "I'm too sick." I told her, "Read it, suck it

"It is a part of life that at times you won't be feeling your best."

up, take some Echinacea, and deal with it. Material like this doesn't come around that often. You have to make it in here." She did, and the rest is history.

Another pet peeve of mine is actors asking me about callback dates or shoot dates. The work dates are almost always released on the breakdown. Look at the email your agent has sent you or at the breakdown itself, which most actors seem able to access. If you can't find the answer on your own, then it's a perfectly legitimate question to ask the casting assistant sitting at the front desk.

And here is a piece of business advice: Be kind to casting assistants. Why not ask their names? If the associates are not on the phone, why not smile and say hello? They will be casting on their own in a short time and are already influential with the casting director. We have long memories in this business. I was the casting assistant on the movie *Blue Velvet*, and I still

remember the actors who were nice to me. The associates are the people who will upload the audition onto the computer and assist in picking the best takes. It is good business to acknowledge their presence. If they are on the phone and stressed, a smile is enough—it can go a long way.

Asking, "when are callbacks?" can come across as presumptuous because you appear to be assuming that you will be called back. Think of an audition as a first date. Would you ask your date if he is going to call you? No, if your date is interested, he or she will take action to keep the relationship going. An audition is not just an opportunity for directors and producers to see if they want to work with you; it can also be *your* opportunity to see if *you* want to work with them. When I worked in theatre, I always advised actors of their rights. You can check out a director's vision and get a sense of his or her style during an audition. If the director is an asshole to you in the room or you completely disagree with the direction, follow your instincts and pass if you are offered the job. Have no fear, if you are talented and right for the next role, you will be asked back by the casting director. You have every right to put yourself in a setting where you will succeed and be supported. I don't recommend showing up for a callback if you don't plan on accepting the job, however.

One last pet peeve is when an actor (usually a woman) looks nothing like her headshot. As far as I'm concerned, it's deceitful and unprofessional. You are given the opportunity to audition because a casting director responds to your picture or résumé and wants to give you a chance. The casting director is expecting a reasonable facsimile of the photograph when the actor walks into the room. I often kid, "Wow, I want that photographer!" when an actor looks nothing like his or her headshot. Men often use very old pictures of themselves. Try to keep your headshot updated to within two or three years. Young adults or children should update their pictures every year.

What is the most common mistake that experienced actors make?

Most experienced actors do too much. Ninety percent of the time, I end up directing the actor to act less and make the audition cleaner and simpler so that the text and the through-line of the scene are clear. The impulse comes from a good place. The actor is creative and talented, has a body of work behind him, and is making strong choices. He is trying to convince his audience that he is the character. He wants you to appreciate his instrument. It all makes sense. But no matter how amazing your instrument may be, that is not what an audition is about.

Most acting teachers will tell you, "The audition is your time. It's all about you." It's not. It is about

the text and the scene, and you are there to serve the text and further the story. An actor can still make distinctive choices, provide multiple colors, and create a unique character. An experienced actor may want to tackle a complex character in a genuine and creative way, but sometimes simple and honest is best. The camera catches everything, so a simple choice is often the strongest and most authentic. You don't have to play tough to be tough, at least not if the scene is well written. The toughness will be inherent in the writing. Subtle choices are usually the ones that lead to memorable and true moments.

An actor also needs to realize that, while the scene may be played out with more emotion or on a bigger scale on set once the actor has the job, this is the audition, not the actual job. It's taking place in a small room, and 99% of the time the director/producer is watching the audition on a small computer screen. That is a very different experience from watching a big screen or a live rehearsal. Even when a producer/director watches auditions on a big screen (as many of my clients do), subtlety remains important.

I understand why an actor often has an impulse to do too much. He or she has worked hard on the audition and is somewhat over-energized when he walks into the room, especially if he really wants or cares about the job. When I'm alone in a room with

an actor, I will always have the actor do a second take to give him a chance to pull back. But many directors won't do that because they don't have the time in **prep,** and many casting directors don't do it either. So make sure to get in a quick rehearsal while you are waiting (if need be, find a private corner and do one out loud) to help alleviate this problem.

My answer is always the same when a novice or inexperienced actor asks, "Should I make something of my one line?" or "Should I make a choice that sets me apart so they remember me?" Don't make it about you. Go back to the text and serve it. Your line is one moment in a larger narrative. Keep it simple. Sometimes the audience just needs to believe the character is performing a typical and familiar task. I respect the actor who can disappear into a small role and practically hide behind the words on the page. It's slightly different with larger roles. It doesn't matter as much where the narrative is heading; the character needs to be somebody the audience finds compelling.

"The camera catches everything, so a simple choice is often the strongest and most authentic."

When the competition gets really tough—when many experienced actors are competing against each

other for a lead role in a pilot, for example, especially a much sought-after part—a successful audition will come down to specific traits, tones, and qualities that are needed to fulfill the role. We recently cast a series for AMC, *The Son*. When casting the role of Eli, we needed a sympathetic actor so the audience would empathize with a character who was committing many violent acts. The audience needed to forgive and accept his flaws as a human being. I believe we made the right choice.

How can I follow up on my audition?

After an audition, you will want to know how you did. I understand the need for feedback. We all need it; it is a natural human impulse to want to know if a job was well done. In a way, it's a job interview. But you will usually know instinctively if you did a good job; if you were in the moment and you felt that it worked, you did a good job.

Does that mean you will get hired? Not unless you were the only one auditioning for the role. Remember, my job is to present multiple strong choices to my producers, and there could be any number of reasons why you may not be the right person for a given role on a given day. If a casting director brings you back to audition over and over again and you still haven't booked a job with them, rejoice! It means the casting

director respects and appreciates your work. You and I both know you won't book every role you audition for.

To quote a line from episode #206 of *Halt & Catch Fire*, "The hardest thing in life is to get knocked down and then get back up. Constantly. But we do it!" Many successful actors fail for a long time before anyone pays attention to them. We all hear about the "instant success," because that story sells more magazines, but the truth is that many accomplished actors struggle for a very long time. You can't rush success. There is something so sweet in the reflection of *earned* success when it comes after a lot of hard work.

I brought in one actor over and over again for fifteen years before I finally hired him. This was John Diehl, whom I had first seen in an early production of *Lie of the Mind*, a Sam Shephard play at the Mark Taper Forum, and who was in the cast of *Miami Vice*. When he told me how long he'd been coming in to audition for me, I was more embarrassed then he was. He knew that I believed in him, and he never turned down the opportunity to audition.

How do you get feedback if you really need it? If you are really unsure how your audition went, your agent or manager can call for feedback, but even they won't always get the answer. You must understand the nature of a busy casting office; if every agent called for

feedback, I wouldn't be able to finish the rest of the work required to cast a show.

As previously mentioned, I have taken notes on every actor's audition since I started casting over 29 years ago. These notes help me remember actors and serve as my *CliffsNotes* when deciding whether to bring them in for future roles. When I do have time to give feedback, I use these notes to let the agent know what exactly went on in the room. If you don't have an agent or man-

> *"Your career should not be defined by rejection, nor should it be defined by the jobs you book. It should be defined by the ability to rebound from your perceived failures. You can't rush success."*

ager, I don't recommend your calling directly for feedback. The feedback will be obvious when you come into the same office for another job.

At the end of the day, I do understand the sting of rejection. Casting directors also have to audition or interview for jobs, and we don't get every one that we want. We prepare with precision, research, and imagination. Your career should not be defined by rejection, nor should it be defined by the jobs you book. It should be defined by the ability to rebound from your perceived failures.

After an audition, you may also want to know how to stay in touch. I happen to like getting mail. Maybe that's one of the reasons I became a casting director. I look at every piece of mail I receive, from postcards to personal notes. If you send a thank you note, always make sure to send a small picture with it so there is an instant identification, especially if it's the first time you have met the casting director. Though postcards usually end up in the circular file (aka the trash can), they do get read first. Often fate turns its head when I hand a postcard to my associate or my partner and say, "You should bring this actor in for such and such," and they do.

There is no need for thank you gifts (yes, we get them). Finding the right actor and hiring him or her for a role is my job. What I appreciate most is a hand-written note. It's nice when someone takes the time to acknowledge a positive interaction, especially if I went out of my way to help him or her get a job. I still have on my wall Michael McKean's thank you note for casting him in an episode of *The Unit;* he had always wanted to go on a mission with soldiers.

Conclusion

Auditions are an opportunity to do what you love best: Act! It doesn't matter if you're acting for five minutes or five hours. It's a time to live more vividly in an actual existence than in your dreams. The audition is your chance to play, to go back to being a kid again, to assume another role, and to have fun pretending. As an actor you have the gift of being able to enter a fantasy world. Try to find your way back to the reason you are doing this in the first place. Remember that the creative process is as important as the result.

Find joy in creating a new character for every audition. If you do, the experience will become positive, even fun. That joy will be contagious, and the camera will definitely pick up on it. I certainly do. Perhaps that's the root of the saying, "The camera never lies."

Find a ritual you can practice when it comes to auditioning, and remember in detail what works for you. The more auditions you prepare for, the more

your process will evolve. And if someone comes along to help you tweak it, accept it as progress.

Potential can be a burden if it winds up being unfulfilled, so audition for everything you can, especially at the beginning of your career. Immerse yourself with the best. How? Do two lines with a great actor rather than ten pages with a mediocre one. I cast actors who were thrilled to do two lines with Tim Roth in the television series *Lie to Me*. They were actors capable of way more, yet they all confessed that the experience was worthwhile and a complete joy. I have seen actors (much to their agents' chagrin) turn down big paychecks for multiple episodes on television shows in order to do a single scene in an episode of *The Unit,* directed by David Mamet. (Plato said, "A good decision is based on knowledge, not on numbers.") Study with the best teachers and do readings with working actors. If you have the opportunity, volunteer to be a reader in a casting office— you will learn more in an afternoon than in a year of

> *"I believe this is the golden age of television—especially in cable television—for writers, actors, and directors, and I'm not the only one who believes this."*

lectures. Read, rehearse, read, rehearse, and then read and rehearse some more.

Continue to take ego out of the equation and make it about the work.

I've heard actors say they only want to work on film, not television. I think that's a mistake. I believe this is the golden age of television—especially cable television—for writers, actors, and directors, and I'm not the only one who believes this. Consider the famous filmmakers who are now working in television: Michael Mann, Frank Darabont, David Fincher, David Lynch, Barry Levinson, Steven Soderbergh, and Steven Spielberg, to name a few.

TV has become so sophisticated in its story telling: Look at the shows *Breaking Bad, The Walking Dead, Homeland, Game of Thrones, Downton Abbey, Boardwalk Empire, The Night Manager,* and even *The Good Wife* (one of my favorites on network television). Why are film stars like Ewan McGregor, John Turturro, Matt Damon, Tim Roth, Kevin Bacon, Dennis Quaid, Laura Linney, Claire Danes, Glenn Close, and Academy Award winners Mary Steenburgen, Angelica Houston, Kathy Bates, Gwyneth Paltrow, Dustin Hoffman, and Al Pacino migrating to television?

Harking back to my earlier comparison of actors with athletes, you don't have to hit one out of the ballpark every time you're at bat. Actors are attracted to

the medium of television because they're given weeks to develop a character, time to involve the audience as the character grows and changes on screen. Witness Bryan Cranston's transformation from high school chemistry teacher to lethal drug dealer during five seasons of *Breaking Bad*.

Survival in the entertainment industry is difficult. I think acting is the most difficult of the arts. There are many choices to be made for survival in this business. One can choose to build a hard and tough exterior (and you have every reason to do so) or a more reflective or spiritual one. I suggest the latter. Introspection makes poets of us all. It can remind you to be an artist. Understand your art, and separate it from the business.

Keep the acting muscle active however, wherever, and whenever you can. You don't want it to atrophy. I always advise actors to keep working in theatre, where the writing has stood the test of time. *Glengarry Glen Ross* is as relevant today as when it was first performed on Broadway in 1984, and Mamet and Pacino reunited and put it up on Broadway again in the fall of 2012. In the theatre, you might not get typecast as television and film tend to do, and you will be afforded the time and the rehearsal to develop an array of characters.

And remember to celebrate. Celebrate the journey. Celebrate leaving an audition and feeling good. Celebrate meeting new artists when you get the chance

to be in front of a director and a writer. Celebrate each job no matter how small. Celebrate meeting a new casting director.

When you book a job, make sure you get the word out either by postcards to casting offices or an announcement using social media (if allowed by the show). The window of time to capitalize on such momentum is short; use the opportunity for self-promotion. Whether it's your first job, your first guest star, your first pilot, or the first time you walk out of an audition and realize you accomplished what you intended to do, rejoice.

And if it's not any fun, go do something else, something easier. Good acting may look easy and seamless, but the best actors know it takes a lot of work to get there.

Glossary

Actors Access
A membership-only website for actors that is updated daily with casting information released by its parent company, Breakdown Services. Only those projects for which a casting director has granted permission to release the breakdown are included.

Audition Room
The space in which an actor is asked to demonstrate his ability for a particular role. In addition to the actor and casting director, a reader, camera operator, producer, writer, and/or director may be present. Often called the taping room.

Blocking
The process of planning where, when, and how actors will move about the set during a performance.

Breakdown Express
A website that connects casting directors and talent representatives (agents and managers) with Breakdown Services. Breakdown Express delivers casting information to talent representatives instantly throughout the day. After talent representatives view the casting information, they can submit their clients' pictures, résumés, and videos via Breakdown Express to casting directors.

Breakdown Services

An organization that publishes detailed casting information to legitimate representatives of talent. Includes restricted member access, open calls, links, online store, and contacts. Also the owner and operator of Actors Access.

Callback

A second audition, in which selected actors from the initial audition are invited back. The actor will often read in front of the director, producer, and/or writer, in addition to the casting director, as the decision on who to cast is narrowed.

Casting Associate

Works under a casting director and participates in casting sessions; often runs pre-read and/or producer/director sessions; negotiates actor deals and helps generate creative casting lists.

Casting Society of America

The Casting Society of America is the premier organization of casting directors working in film, television, and theatre. Although it is not a union, its members are a united professional society that consistently sets the level of professionalism in casting on which the entertainment industry has come to rely.

Co-star

A supporting role, usually just a few lines in a single scene or multiple scenes. A co-star is a smaller role than a guest star and is billed accordingly.

Dialect Coach

A dialect coach works with an actor to perfect a regional or foreign accent for a role, focusing on pronunciation and phonetics.

Executive Producer

An executive producer for a television series oversees all aspects of the production—including creative, financial, and logistical—from development through completion. While writers often head a television series, the executive producer is ultimately in charge of the creative and business components and corresponds with the network or company financing the project. Many executive producers may be credited on a television show, often including a production executive or financier, head writer, and show runner. In feature films the executive producer is rarely the writer, but he or she still retains all the responsibilities listed above.

Extras

Actors who appear in the background with no lines.

Extras Casting Director

The casting director in charge of hiring all the non-speaking roles that appear in the background of a scene.

IMDb (Internet Movie Database)

An online database of information related to films, television programs, actors, production crew personnel, video games, and fictional characters featured in visual entertainment media.

IMDb Pro

A more detailed online database of credits, background, and contact information for industry-wide film and television professionals as well as projects in development and pre-production.

Guest Star

A guest star plays a major role in a single episode of a TV series, usually shooting several scenes, often over multiple days. A guest star's name may appear in the billing in the opening credits or in the end credits. Although sometimes celebrities appear as guest stars, unknowns are often cast in large guest star roles.

L.A. Casting

An online casting service—part of Casting Networks—on which casting directors can post auditions. A section of the site called DirectCast makes a portion of the breakdowns available to actors.

Manager

A talent manager is a professional engaged in advising and counseling the actor. A manager works closely with the actor in every facet of his or her career and acts in conjunction with the actor's agent. Managers take a negotiated percentage of the actor's salary. Managers are not regulated, nor are they required to have a license. Under law, managers may not procure employment for artists or negotiate without a licensed agent.

Network Executive
A person employed by the network. Duties can range from overseeing casting, developing a show, assisting in scheduling, and working with writers and directors on the tone and direction of a show.

Now Casting
A national online casting site used by many studios and networks, on which casting directors can post auditions and watch and organize auditions electronically.

Off book
A term describing the work of an actor who has memorized the script and no longer needs or uses it to perform.

Pilot
A stand-alone episode of a television series (often the first episode) that is used to sell the show to a television network. (In some cases it is commissioned by the network.) At the time of its creation, the pilot is meant to gauge whether a series will be successful, and is therefore a test episode of an intended television series.

Pilot Season
The time period when most television pilots are cast, traditionally January through March to prepare for spring shooting. With the proliferation of cable networks, pilots are now cast all year long, although the networks still cast the majority of their pilots during the winter.

Prep
Usually refers to the pre-production period before filming for a movie or television show begins.

Producer
In television, the producer can often be the writer. The members of the writing staff who significantly contributed to the final script are often credited as producers.

Reader
The person who reads the sides opposite an actor in an audition, typically hired by casting.

Residuals
Payments made to the creator or performer for subsequent showings or screenings after the completion of the project.

Second Screen
The use of an additional monitor (i.e. laptop, tablet, smartphone) while watching television, a movie, or video game. It allows the audience to interact with or discuss what they're watching, often through social media.

Self-Taping
The process whereby actors video themselves in their own homes or studios, without the assistance of a casting director.

Series Regular
A main cast member of a television show around whom the storylines revolve. Regulars receive top billing and are under contract to the show. An actor can be hired as a series regular or be promoted from a recurring role.

Show Runner

Usually refers to the executive producer or supervising producer in the television industry who is responsible for running the day-to-day operations of a show.

Sides

A scene or number of scenes, usually taken from a script, that an actor uses to prepare for an audition. Sides are sent by the casting office to actors or their representatives or are made available online.

Single Episode

An individual section into which a television program is divided, either a half-hour or hour in length, involving a different scenario each week. Episodic television relies more on stand-alone episodes, while serial programs follow main story arcs that unfold from episode to episode.

Sitcom

Short for "situation comedy." A half-hour television comedy made up of a group of characters sharing a common environment such as a home or workplace. The dialogue is accompanied with jokes, and the humor is typically derived from people being placed in uncomfortable or unfamiliar situations. A sitcom can be shot in a single-camera style (e.g., *Curb Your Enthusiasm* and *30 Rock*) or in a multi-camera style in front of a live audience (e.g., *Two and a Half Men*).

Slate

The opening (or sometimes the closing) of a video audition, in which the actor states his or her name and the part he or she is reading for.

Stunt Coordinator

An experienced stunt performer who arranges for casting or works closely with the casting director to arrange for and supervise the stunts to be performed in a television show or film. Stunt coordinators work closely with the director and are instrumental in the decision on who to hire for the stunt written in the script.

Studio Executive

An employee of the studio who takes responsibility for a variety of aspects of the project ranging from budgeting to approval of all key personnel.

Talent Agent

An actor's representative whose job is to create opportunities and procure and negotiate employment for actors and counsel them in the development of their careers. The state, city, or appropriate governing body must license agents in most states. Agents without a license may have their contracts invalidated and are forced to relinquish any commissions paid. The standard fee is ten percent of the actor's salary.

Variety

A daily entertainment trade magazine and paid website containing all the latest news and reviews from the entertainment industry and offering searchable archives, interactive box office charting, international box office grosses, a credits database, film and television production charts, an in-depth industry calendar, and reviews dating back to 1914.

Audition Checklist

Before you leave home:

1. Review the appointment information; make sure you don't have any conflicts with the date and time.

2. If you receive advance notice of who will be in the audition, write down names so you remember them.

3. Bring printed copies of your photo and résumé.

4. Sides/script: Bring a printed copy, not just the version on your phone or iPad.

5. Directions to the audition: Print a hard copy in case your phone loses service en route.

6. Bring a photo ID; many audition locations require one for security reasons.

7. Pack a change of clothes in your car or bag with different color shirt/shoes.

8. Women should bring a makeup bag with a hair tie/rubber band.

9. Remove perfume or aftershave and any excess jewelry not appropriate for role.

10. Pack gum or breath mints.

And remember:

1. The first audience member you need to satisfy is yourself.

2. Be as familiar as you can be with the project for which you are auditioning: the tone of the show, the arc of the character, the importance of a scene in the context of the story.

3. Memorize the first line, the last line, and something in the middle. That way the camera starts and ends on your face.

4. If you leave your picture in the car, you'll never get on the casting office wall. The goal of an audition is not to book the job but to be remembered and brought in over and over again by the casting office.

5. It isn't necessary to dress for a role, but if it helps you get into character, then by all means do so.

6. Hang on to your confidence and inner voice; they will serve you in the long run.

7. Every audition room, no matter how friendly or unfriendly, provides you an atmosphere in which to create truth from illusion with the text you have been given. Go with the flow, and expect every situation to be unique. All you can control is your work.

8. A successful audition should illuminate both the actor and the character, but it's the character that is most important.

9. If you have a non-American accent and are auditioning in America for an American role, it's best to come in sounding American.

10. When a role demands an accent, your ability to speak with the required accent will be a big factor (but never the only factor) in the casting director's choice.

11. Actors sit for auditions 75% of the time, but the choice is yours and may change from scene to scene.

12. Don't ask a question of the casting director if you should already know the answer.

13. When you're given even a brief opportunity to pause between scenes and focus on what you want to accomplish in the next scene, take it.

14. If you start off camera, *don't* start the dialogue until you are in frame. Given so little time to establish a character, you want every moment on camera you can get.

15. Ignore unrealistic stage directions. Don't mime a kiss, for example. Focus instead on what your character wants and says, and let go of worrying about anything else.

16. If you have only one reader in the room for a multiple-person scene, look at him or her for each character other than your own. It's a lot easier to connect with another person than with a wall.

17. Play to the size of the room. Since you are being filmed close up, every movement you make needs to be economized for its effect on camera. Bigger is not always better.

18. If you make a distinct choice, one that serves the text, you will be remembered. Something as small as a glance at the ceiling, a smile, a laugh, or a certain way you pause can make you stand out and get a role. Casting directors call it the actor's signature. Give at least three truthful moments, and you will have done your job.

19. Your job as the actor is to improve upon the writing, not by rewriting, but by adding nuance and shading.

20. You can start over if you slip up, or you can use the slip as an unintentional gift that places you in the moment. You may just have created the most believable and original moment of your audition. Trust your instincts. And remember: Directors and producers want you to succeed.

21. Keep your focus on the material, not on who is in the room.

22. Do not despair or be insulted if no director or producer is in the room for your audition. It does not mean your audition has been prejudged or given low priority. Some actors even do better without the pressure of producers watching them audition. Casting

directors are often more relaxed without the stress of many voices in the room.

23. If you're given sides for a role you're not auditioning for, speak the lines as if they're coming from the character you'd be playing.

24. Yes, you can create your own content and put it up on the web, either as a webisode series or a series of home videos. It's one of the reasons why being an actor at this time in the history of entertainment is so thrilling.

25. Thanks to the increasing acceptance of self-taping, you do *not* have to live in New York, LA, or London to book a job in television, film, or new media.

26. Don't walk into the audition room unprepared.

27. The camera catches everything, so a simple choice is often the strongest and most authentic.

28. Your career will not be defined by rejection or by the jobs you book. It will be defined by your ability to rebound from perceived failures.

Acknowledgments

This book could not have been written without the help of some talented and dedicated people. First, TGIHL, which stands for Thank God I Have Lizza. My primary assistant in this book's original edition, Lizza Monet Morales, brought me forward into the twenty-first century of technology. Her enthusiasm, intelligence, and guidance lit the spark for all the energy it took to write the guide. My heartfelt appreciation goes to my amazing casting partner, Sherry Thomas, aka "Wonder Woman," an extraordinary casting director who makes coming to work every day a joy, and to my hardworking and talented casting directors on staff, Gohar Gazazyan and Russell Scott, who keep me on track and remember everything that I can't and more. My associate, Stacia Kimler, and my fantastic assistant Alyssa Morris make me a better casting director every day. Big thanks to the actress Ella Dershowitz, who supplied me with such thoughtful questions for the original edition and who read my first draft. She made it so much better that I wanted

to sign up to take an SAT class with her. Thanks to our former intern, Paul Divito, for some of the questions in the guide. Thanks are due to my son Josh, who graciously answered questions any time of day on any topic from current events to technology and gave me the encouragement I needed to keep on writing. Many thanks to my amazing daughter Michelle, whose boundless energy and artistry overflow into her mother's psyche. I am so grateful to my mother, Ann Bialy, who got me interested in casting when she watched the 4:30 p.m. movie with me every day after school and taught me the names of all the actors. And to my brother Mark, who snuck me into the second half of every Broadway show in the 1970s and lit the spark of my love for the theatre—especially second acts. Thanks also to my friends Gary and Lisa Foster, who constantly encouraged me, and to Carolyn Cohen, Alan Dershowitz, Susan Berman, and Brian Grandison. I am indebted to my attorney (and author of *Saving Sammy*) Beth Maloney. I have learned always to adhere to her words of wisdom. And to my editor Tris Coburn, who understood that I have a demanding day job but never gave up gently pushing me to keep moving forward.

My appreciation goes to all the writers, directors, and producers who I have worked with through the years. They have inspired me, driven me crazy, and

have always taught me what it means to work hard to produce a great product.

I must extend my utmost gratitude to David Mamet. When I told him about my idea for a book, and that I was worried I couldn't write, he said, "It doesn't matter, it's a fucking great idea." When I told him I was having trouble disciplining myself to sit down and write, he told me to stand up and do it. And a special thank you to Billy Ray, the writer/director who reminded me what a great collaboration with a casting director can mean to the entire process of filmmaking.

My greatest debt is to the actors, young and old, who continue to motivate me to come to work every day. Their job is the hardest, and I am constantly in awe of their talent, bravery, and courage to be vulnerable in an audition room and have it recorded on camera for all to see.

SHARON BIALY began her career in 1986 as a casting assistant in commercials. She segued into theatre and film, first as the casting assistant on David Lynch's *Blue Velvet*. She worked as an associate for Rick Pagano, then became his partner, casting for over a dozen regional theatres including Lincoln Center, The Old Globe, Actors Theatre of Louisville, Denver Center Theatre, The Guthrie, and South Coast Repertory Theatre. She continued a 15-year relationship with Des McAnuff at the La Jolla Playhouse, which led her to her first Broadway credits, *A Walk in the Woods*, *Jersey Boys*, and *The Farnsworth Invention*. She also did the West Coast Broadway casting for David Mamet on *Race*, *The Anarchist*, and *China Doll*.

She has cast a wide variety of studio and independent features including *Drugstore Cowboy*, *Child's Play*, *Fire in the Sky*, *Don't Tell Mom the Babysitter's Dead*, *Point Break*, *Rudy*, *Mr. Holland's Opus*, *Blood In, Blood Out*, *Indian Summer*, *Rock Star*, *Reign O'er Me*, *Red Belt*, and the remakes of *Straw Dogs* and *The Secret in Their Eyes*.

Favorite television pilots (all picked up to series, which she also cast) include *Young Riders*, *Picket Fences*,

The Pretender, Mind of the Married Man, The Unit, Jericho, Crash, Lie to Me, Detroit 187, Pan Am, Breaking Bad, The Walking Dead, Gotham, Halt & Catch Fire, Better Call Saul, Vice Principals, The Son, and *The Handmaid's Tale.*

Ms. Bialy has been nominated for sixteen Artios Awards (she won for *Breaking Bad* in 2015) and was the recipient of the 2011 CSA Award from the Media Access awards. She was nominated for an Emmy along with her partner, Sherry Thomas, for *Breaking Bad*'s final season. She is a member of the Television Academy of Arts and Sciences and The Academy of Motion Pictures. A former voting member of the LA Stage Alliance Ovation Awards, she sits on the National Advisory Council for Journeys in Film. She was a contributor to *LA Family Magazine* with her column "The Kids Casting Corner." She was a board member of the Casting Society of America for four years, from 2012 through 2015.

She is the author of the soon-to-be-published *How to Self-Tape Your Audition* (with interactive links) and the novel *I Never Had a Couch: Tales from Behind the Door of a Casting Office.*